IMAGES OF ASIA

Modern Chinese Art

Series Editors, China Titles:
NIGEL CAMERON, SYLVIA FRASER-LU

Modern Chinese Art

David Clarke

OXFORD
UNIVERSITY PRESS

OXFORD
UNIVERSITY PRESS

Oxford University Press is a department of the University of Oxford.
It furthers the University's objective of excellence in research, scholarship,
and education by publishing worldwide in

Oxford New York

Athens Auckland Bangkok Bogotá Buenos Aires Calcutta
Cape Town Chennai Dar es Salaam Delhi Florence Hong Kong Istanbul
Karachi Kuala Lumpur Madrid Melbourne Mexico City Mumbai
Nairobi Paris São Paulo Singapore Taipei Tokyo Toronto Warsaw

with associated companies in Berlin Ibadan

Oxford is a registered trade mark of Oxford University Press

Published in the United States
by Oxford University Press Inc., New York

British Library Cataloguing in Publication Data
available

Library of Congress Cataloging-in-Publication Data

Clarke, David J. (David James), 1954–
Modern Chinese art / David Clarke.—1st ed.
p. cm.—(Images of Asia)
Includes bibliographical references and index.
ISBN 0-19-590606-3 (alk. paper)
1. Art, Chinese—20th century. I. Title. II. Series.
N7345.C59 1999
709′.51′0904—dc21
99 35800
CIP

Printed in Hong Kong
Published by Oxford University Press (China) Ltd
18th Floor, Warwick House East, Taikoo Place, 979 King's Road, Quarry Bay
Hong Kong

Contents

Acknowledgements

This book is dedicated to my brother Phil.

I WOULD LIKE TO RECORD HERE my thanks to all the artists, museums, private collectors, and publishers who have helped me by providing either photographs or permission to reproduce illustrations. For the most part, their aid is acknowledged in the captions of the respective illustrations (except where they wish to remain anonymous), although the indirect but important assistance given by Christina Chu, Kao Mayching, and Chen Yi-feng needs to be mentioned here. Karen Leung, Yan Pui Ling, and Edwin Leung of the Department of Fine Arts, The University of Hong Kong, have given me unstinting support at all times, and Chan Kuen-on helped me immensely when I was in the final stages of preparing the manuscript. It would be impossible to record here all my intellectual debts, but I would particularly like to acknowledge the encouragement I received from both Hsio-Yen Shih and Kerrie MacPherson back when I was just beginning to engage in research on twentieth-century Chinese art. The research on which this book is based was supported by a grant from the Committee on Research and Conference Grants, The University of Hong Kong.

Introduction

FOR SOME TIME is was common for art historians to talk of a tendency in Western art of the later nineteenth and twentieth centuries towards greater formal purity. In recent years, however, this form-centred model of Western art's development has come to seem less viable. Scholars have rejected the idea of a unified narrative of progress, gaining in the process an appreciation of the actual heterogeneity of twentieth-century European and American art. Issues of content or meaning have come to be discussed, not just those of form or style, and art has been conceived of as both influenced by broader social and intellectual factors and, in turn, as commenting upon the world around it.

This shift of paradigm enables non-Western art of the twentieth century to be considered on equal terms with its Western counterpart. No longer condemned as out-of-date for failing to share Western art's concern with formal issues, it can now be seen as offering an equally rich response to the modern condition. If we understand modernity to mean urbanization and industrialization, and indeed all of the radical socio-economic transformations caused by the development of capitalism, then China (like other non-Western countries) has certainly experienced modernity. Indeed, it arguably underwent a more extreme and traumatic break with the past than had Western Europe, since so much of the impetus for change came from external forces.

It will be the task of this book to describe the particular ways in which Chinese art responded to the modern experience, thereby expanding our conception of what 'modern art' can be. My contention is that all of Chinese visual culture was influenced by the broader transformations in society which occurred in the twentieth century, and thus I will be

de-emphasizing the distinction often made between 'modern' and 'traditional' art. I will not be confining my attention solely to those artists who have attempted self-consciously to be 'modern' but will also look at artistically rich responses to the modern experience made by artists who might at first glance seem quite 'traditional', especially to Western eyes. I won't be assuming that the painting commonly characterized as 'modern' is any less Chinese than that characterized as 'traditional', even though the former is often described by Chinese commentators themselves as *xihua* ('Western painting') and the latter as *guohua* ('Chinese painting' or 'national painting'). Responses to the West play an important part in the story of twentieth-century Chinese art, but, I believe, borrowed elements are always used to produce local meanings. Equally, twentieth-century artists do show an interest in earlier Chinese art, while using it in ways that are specific to their own age.

Whilst it is my hope that I will be able to raise a wide range of issues concerning the interpretation of twentieth-century Chinese art, a slim volume of this kind cannot expect to offer a systematic art historical survey. My more limited aim is to give a broad overview, to provide a map that identifies enough landmarks for the reader to feel confident enough to make his or her own investigation of the fascinating territory that is twentieth-century Chinese art.

For convenience, I will be adopting a broadly chronological approach, breaking my discussion down into five short chapters. I will begin by looking at some of those artists from the earlier part of the century who retained a strong relationship in medium, style, and subject with Chinese art of earlier eras. This will be followed by a discussion of those early twentieth century artists who made a more conscious break with the Chinese artistic heritage, primarily looking

to the West for resources with which to reform their country's visual culture. My third chapter will consider that art of the later Republican period which had a more directly political nature. It will also look at art in the People's Republic of China (PRC), where political considerations were never far away, focusing on the period up to 1976. By contrast, the following chapter will consider the contribution of overseas Chinese artists, as well as those based in Hong Kong and Taiwan. Finally, I will look at more recent developments in Chinese art, including those which have occurred in the PRC following its post-Cultural Revolution economic liberalization, and subsequent growth towards superpower status.

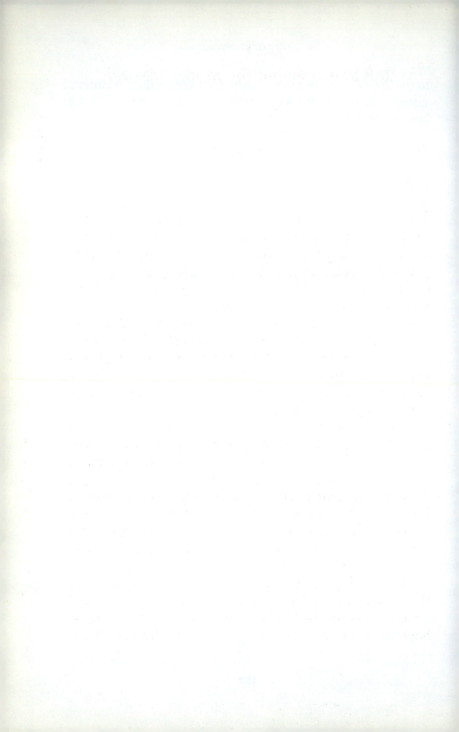

1

Ink Painting and the Modern World

To the Western spectator, Chinese ink painting has often seemed lacking in historical development. Whilst this view may be comforting in that it preserves the West's sense of having a monopoly on progressive change, it cannot be sustained on closer inspection. In the earlier part of the twentieth century, for instance, a significant number of Chinese artists began to feel that there were limitations to the artistic language they were inheriting, but only some amongst them chose to abandon it altogether in favour of a visual syntax taken from Western art. Others attempted to reform the language of ink painting itself, sometimes even introducing consciously 'modern' elements. This chapter will focus on the work of these artists, demonstrating that a blanket labelling of twentieth-century ink painters as conservative or traditionalist fails to do justice to the many dynamic works they have created.

Whilst innovations in ink painting during the earlier half of the twentieth century are of course due to the conscious efforts of the artists involved, it is important to understand that there were radical and irreversible changes occurring in the whole environment in which ink painting was operating. It was inevitably going to have a different place in Chinese cultural life no matter whether or not artists made significant modifications to style or subject-matter. Chief amongst these changes, perhaps, was the rise of a new class of patron.

The most highly valued art of the dynastic era had been that created for (and sometimes by) the literati élite and circulated within their private social spaces. Increasingly, however, with the development of capitalism in China,

bourgeois patrons were playing an important role. The market-place was mediating the contacts of artists and their clients more than it ever had before, and painters who in an earlier age would have claimed the status of amateurs were now openly publishing price-lists instead. During the eighteenth century the members of the bourgeoisie had already played a significant role in making Yangzhou an artistic centre, but their role as patrons became even more clearly evident in Shanghai during the later nineteenth and early twentieth centuries. This most economically developed of Chinese cities was—not coincidentally—the first in the twentieth century to see a major transformation in Chinese painting.

Amongst the Shanghai-based artists responsible for this revitalization of ink painting was Wu Changshuo (1844–1927). Showing an interest in flowers and plants as his subject-matter, as opposed to landscape, Wu was able to produce works with an immediate attractiveness. Relying less than was the norm on allusion to earlier art for their appeal, they were accessible to a broader variety of patrons, and even found an international audience of sorts amongst Japanese residents of the city. In style Wu's work was also more direct. He employed colour boldly, whilst his energetic brushwork served to convey the organic vitality of the botanical subject-matter as much as to describe its form.

Calligraphy, of which Wu was also a skilled practitioner, had encouraged this spirited handling of the brush. Wu frequently placed a calligraphic inscription on the painting's surface as one component of what was often an inventive design, making use of empty white space as a positive element rather than a mere background. Such a practice can be seen in *Peony, Narcissus, and Rock* (1889)(Plate 1), a very economical work in which brushed marks are contrasted to

washed areas. The three-dimensional form of the rock is suggested entirely through variations in the density of a spontaneously applied ink wash.

The paintings of Qi Baishi (1863–1957) commonly share the uncluttered nature of Wu's *Peony, Narcissus, and Rock*, although he appears less adept at making the bare white areas of the image into an active part of the composition. Like Wu he favoured bold spontaneous brushwork, and the preference for approachable subject-matter seen in Wu's work is even more pronounced in the case of Qi. Qi is particularly well-known for his images of crabs and shrimps, even introducing a whimsical note on occasion. A down-to-earth, folk dimension to his work might be attributable to his humble origins. Whereas Wu was born into a gentry family, Qi was of peasant origins and had been apprenticed to a woodcarver. In his early years he also earned money by painting images of the gods of popular religion.

Qi, who made Beijing his home in later life, often showed a preference for tall, narrow formats. The hanging scroll *Eagle and Pine Tree* (Plate 2) is a case in point, and in this work the verticality of the format is emphasized by the image of the tree trunk, which extends almost from the bottom to the top of the image. This trunk reads as a vertical accent (no matter the direction of the individual strokes out of which it is constructed), and its form is echoed by three columns of calligraphy (which of course must be read downwards). The eagle perched on top of the trunk faces right, offering a counterpoint to the leftward veering of the uppermost section of the tree. The great bird is painted, quite appropriately, in greater detail than is the trunk, thereby creating a contrast of brushwork. The energetic marks which describe the trunk are individually legible as traces of the artist's hand. The white showing through certain of the strokes (which vary in

both darkness and wetness) makes us aware of the contact between brush and paper by means of which they were produced, as well as imparting a sense of gestural vitality. At the same time, however, these brush strokes serve a representational function, indicating quite effectively the roughly textured surface so characteristic of pine trees.

Huang Binhong (1865–1955), unlike Wu and Qi, made landscape painting his primary focus (Plate 3). Over his extraordinarily long career Huang worked hard to give new life to this central genre of Chinese art, which in the later part of the Qing dynasty (1644–1911) had often been practised by artists of a stiffly academic nature. A conscious reformer, Huang argued that modern painters must explore new ways, finding their own mode of expression rather than remaining passively within boundaries defined in the distant past. He denounced the 'Four Wangs' (early Qing artists whose work had been the model of much uninspired landscape painting) for producing images of a fragmented nature. Their mountains, he wrote, were just heaps of small stones piled on top of one another, and their brush marks and ink washes lacked integration with each other.

Above all, Huang called for paintings permeated with dynamic energy, paintings that seemed to have a life of their own. In search of this goal he produced images which emphasize organic unity over descriptive detail, and which strive for a rhythmic balance between masses and voids, enabling the image to breath. Huang characteristically built up his masses through a complex layering of ink. Wet and dry, light and dark, washes and brush strokes might all be present, and as a consequence the masses seem alive and in no way static.

One could argue that Huang's penchant for creating a landscape image by the accumulation of small touches is

somewhat reminiscent of Impressionist practice. He was certainly aware of developments in Western art and may have taken some inspiration from it, since he once expressed the view that there were many similarities between Chinese and Western painting, even despite the differences between the tools and materials used. Evidently, however, Huang did not believe that direct borrowing from Western art was the solution to the developmental needs of Chinese ink painting, and instead he found resources for his stylistic innovations by means of extensive investigations in Chinese art history. This was a path to renewal followed by other twentieth-century Chinese ink painters, such as Zhang Daqian (Chang Dai Chien, 1899–1983), who spent the troubled war years of 1941–3 copying Buddhist wall-paintings in the remote Dunhuang caves. His close attention to these pre-literati figure paintings provided him with a resource with which to move beyond some of the closures of the literati tradition itself.

Two earlier artists who inspired a great many innovative ink painters of the twentieth century are Shitao and Zhu Da (also known as Bada Shanren), both of the early Qing period. These artists were admired for their individualism, the very factor which had been responsible for their relative neglect until modern times. The spontaneous style of Shitao was a model for Fu Baoshi (1904–65), for example. Fu was able to make a study of Shitao's work whilst in Japan, where at that time it was more highly respected than in China itself. Later he even wrote a book about that artist, who continued to appeal to following generations of modern Chinese painters, arguably as much through his Daoistic writings on art as through the specifics of his style. The Hong Kong-based painter Lu Shoukun (Lui Shou-kwan, 1919–76), for instance, also held him in high esteem.

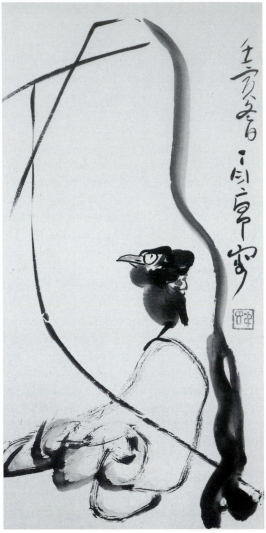

1.1 Ding Yanyong, *Mynah*. 1962. Collection of the University Museum and Art Gallery, The University of Hong Kong.

Zhu Da's influence, on the other hand, is more prominent in the work of Pan Tianshou (1897–1971), who shares the earlier artist's interest in depicting birds, rocks, and fishes (Plate 4). Pan's brushwork is strong and forthright, and his compositions are equally bold, frequently featuring prominent diagonal lines (used to define the contour of a rock, for instance). On occasion his paintings have an austerity which echoes the sparseness to be found in Zhu Da's work. Amongst other twentieth-century artists who turned to Zhu Da for inspiration, one should perhaps mention Ding Yanyong (1902–78). Ding's paintings of birds (such as *Mynah*, 1962)(Fig. 1.1) are intentionally reminiscent of those by that earlier artist, and he often seems to mimic in his work the eccentricity attributed to Zhu Da.

When young, Pan apparently experimented a little with Western painting techniques. Nevertheless, like Huang, he was only obliquely inspired by Western art in his mature work. In a book he published in 1926, Pan commented that Western art of the preceding thirty to fifty years had developed a taste for purity of line and was moving closer in its aesthetic to the East.

The language of ink painting had been decentred or relativized by the increasing awareness in China of Western artistic culture: it was now perceived *as* a language, as one possible mode of visual expression amongst others. This awareness of alternatives, or loss of the feeling that ink painting was the natural and inevitable way to paint, was a change which altered irrevocably the environment in which all subsequent ink painting had to operate. This is true even of more 'traditionalist' ink painters—indeed, one could argue that traditionalism is a specifically modern phenomenon of attempted retreat when faced by the anxiety of choice. In the case of Huang or Pan, though, a more thoughtful and

positive attitude is present. They understood that the art produced in response to the modern experience by Western artists might not have any direct relevance to their own needs.

For instance, whilst one can imagine a Western critic feeling that Chinese artists such as Huang and Pan were 'backward' for not having 'caught up' with Cubism, the most profoundly revolutionary moment of European modernism, in fact the situation of ink painting made most of Cubism's lessons irrelevant. European painting had been dominated since the Renaissance by a desire to produce a strong illusion of visual presence, and so it had utilized unified perspectival schemes in order to make the painted world seem as real as if one were looking through a window. In such a context, Cubism's introduction of multiple viewpoints and its shifting of the viewer's attention from the subject to the means of painting was profoundly revolutionary. But Chinese ink painting had never been obsessed with coherent perspectival illusions, being instead quite happy to accommodate shifts of viewpoint. This is most clearly seen, perhaps, in horizontal handscrolls (which cannot be taken in from a single position because of their extent), but an examination of the buildings Huang includes in a great many of his landscapes will also quickly indicate the absence of any coherent spatial scheme. The lack of such a scheme in Huang's paintings helps to create the dynamism and sense of unity already mentioned as salient qualities of his work.

Many early Western modernists, not only the Cubists, chose to emphasize two-dimensional design qualities as one way of undermining the conventions of illusionistic realism. This tendency is found in the work of Henri Matisse, for instance, who never lets you forget that you are looking at forms and colours on a flat surface, and not, say, at a face or

the interior of a room. But Chinese ink painting of earlier eras already had a strong sense of the painted surface and did not need to learn this from the West. Brushwork is visible as brushwork in Pan's paintings, and an elaborate aesthetic context already existed for it to be evaluated as such. When Huang claimed that true art is that which achieves both complete resemblance and complete non-resemblance (a statement which could be applied to the rock in Wu's painting or the tree trunk in Qi's), he was not placing himself in conflict with earlier Chinese aesthetic theory.

Wu, Qi, Huang, and Pan are all artists who tried to reform ink painting on its own terms. There exists, however, an alternative strategy of reform in early twentieth century Chinese ink painting, that of the Lingnan School artists. These Cantonese painters, of whom Gao Jianfu (1879–1951) is the most significant, were more conscious modernizers than were the artists already discussed, and unlike them they were willing to make direct borrowings from the language of Western art. They turned not to Western modernism, which (as has just been pointed out) has certain qualities in common with the inherited language of ink painting, but to that 'realist' manner which modern art had been reacting against. Given the culturally relative nature of artistic practice, something which appeared out-of-date in one context could prove a resource for change in another.

Gao's *Flying in the Rain* (1932)(Fig. 1.2) is a good example of that artist's efforts to create a modern ink painting idiom. The brush and wash techniques of earlier Chinese art are still to be found, but if we attempted to appreciate the painted marks on their own terms (as Huang or Pan invite us to) we might find them somewhat dull and repetitive. This is because Gao is marshalling the resources of ink painting towards more purely descriptive ends than we have so far

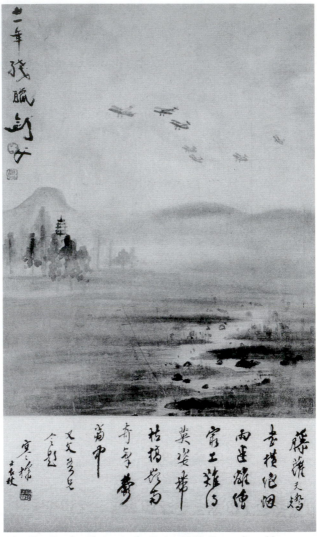

1.2 Gao Jianfu, *Flying in the Rain*. 1932. Reproduced by permission of the Art Museum of the Chinese University of Hong Kong, from the collection of the museum.

seen. In certain of his works he goes quite a long way towards using tonal variations to model fully three-dimensional forms, but this is less easy to discern in an open landscape such as *Flying in the Rain*. Nevertheless, the painting's coherent treatment of space is a logical counterpart to that Western-influenced desire for a sense of solid form. The shifting viewpoint favoured by Huang is eschewed by Gao, and a clearer illusion of depth is the result.

Gao's incorporation within ink painting of Western-derived techniques for realistic representation enabled him to tackle subjects not previously seen in Chinese painting. Although the shift to bourgeois taste, as we have observed, encouraged artists to treat more approachable subject-matter, the Lingnan artists were actively using painting as a way to explore the world around them in a completely novel way. The inclusion of a group of biplanes in *Flying in the Rain* is a case in point. This subject was not only new to Chinese art but consciously modern in its associations. In *A Chinese City in Ruins* (*c.*1937)(Fig. 1.3), Gao depicts the consequences of a 1937 Japanese air raid on an outlying district of Shanghai (Japan invaded China that year). Such topicality of reference was new to Chinese art, as was the willingness to treat subject-matter as negative in nature as this.

Gao's attempt to use ink painting to represent modern subjects was not without its own problems, however. There was a danger that the new subjects would require such a novel treatment that a sense of connection to earlier ink painting would be lost. Gao's decision to place the biplanes in *Flying in the Rain* some distance back in the painting's space seems conditioned by a desire to prevent these symbols of modernity from becoming too overpowering, thereby rupturing the inherited ink painting paradigm. In *A Chinese City in Ruins* the vagueness introduced into the middle

1.3 Gao Jianfu, *A Chinese City in Ruins. c.*1937. Reproduced from *T'ien Hsia Monthly*, Vol. 9, No. 1, August 1939. Present whereabouts unknown.

ground visually obscures the otherwise dominant forms of the architecture, even though this works against the painting's ability to convey its meaning. It is as if the ruins must take on forms analogous to those of the mist-shrouded mountains found in countless earlier Chinese landscape paintings, even if the associations thus evoked are altogether incongruous. In some works the Lingnan artists eliminated conspicuously modern subject-matter altogether, relying instead on calligraphic inscriptions or on allegorical associations (for instance in animal paintings) to introduce contemporary references.

To fully understand Gao's project of reform, one must realize that he was not only attempting to be innovative in style and subject-matter but also in terms of intended audience, and indeed in terms of the whole function of painting as that had been understood in the Chinese context. Gao was attempting to make ink painting a public language for discussion of national issues, instead of the private language of the élite which it had formerly been. Art could be a force for positive change in society, he believed, through its ability to transform human understanding. The inspiration for this view came from Gao's involvement with the revolutionary movement of Sun Yatsen (Sun Zhongshan), who went on to successfully overthrow the Manchu Qing dynasty in 1911, founding the Republic of China (1912–49). Gao had become involved with Sun's movement whilst he was studying in Japan, and in 1908 was sent back to his native Canton (Guangzhou) to do underground revolutionary work. Since he refused high office after the founding of the Republic, art became the principle means for the expression of his political idealism in the years which followed.

A direct link is present between the subject-matter of *Flying in the Rain* and Gao's political beliefs. 'Aviation to

Save the Country' had been a slogan of Sun Yatsen, and a banner proclaiming it was apparently present when a number of Gao's airplane paintings were exhibited in Canton in 1927. Public exhibition, of course, was itself a dramatic change to the conditions within which ink painting was experienced, and a precondition for it to reach new and wider audiences. Public exhibition became increasingly the norm as the century progressed, and the development of art magazines and of art criticism were also important to the creation of a new public space for art in China. Gao himself was involved with running a gallery at one point, as well as with art publishing. Even earlier art was affected by these developments. The imperial art collection, previously only visible to a very narrow audience, became a museum in 1925. Special exhibition galleries were later constructed to supplement the original palace rooms.

Gao's attempt to reform ink painting, and to make it the basis for a 'New Chinese Painting', was only partly successful. As was already indicated, it was not altogether straightforward to introduce modern subjects and Western stylistic elements such as modelling without losing a sense of connection to Chinese culture, and this set limits to the extent of the radicalism of the Lingnan artists. A growing sense of disillusion with the direction of political events after the initial triumph of Sun's revolution may also lie behind the more private flavour of much of Gao's later production. Furthermore, the fact that the Lingnan artists had learnt most of what they knew about Western art at second hand from the Japanese became problematic when that country developed territorial ambitions in China. A recognizably Japanese flavour became an impediment for a consciously nationalistic style. Although the experimentation of the Cantonese Lingnan School artists had been an important

episode in the development of Chinese ink painting, it was to be more conscious Westernizers, with no particular allegiance to the ink painting heritage, who were to prove the most radical reformers of Chinese art in the early part of the twentieth century. Whereas Gao, being a supporter of Sun Yatsen, perhaps saw the alien Qing dynasty as the main impediment to progress, later reformers were to take more direct issue with the Chinese cultural heritage itself.

2
Looking West

THE ATTEMPT OF ARTISTS to reform Chinese painting in the early twentieth century can only be understood when seen as one aspect of a broader project of cultural renewal. Many intellectuals of that time felt that there were deep problems with Chinese culture and society, and characteristically they looked to the West for inspiration when attempting to devise solutions. Cai Yuanpei (1876–1940), Chen Duxiu (1879–1942), and Hu Shi (1891–1962) were amongst the most prominent reformist intellectuals of the age, but perhaps the earliest significant figure was Kang Youwei (1858–1927). In 1898, under the Guangxu emperor (r.1875–1908), Kang had been responsible for instigating a radical programme of reforms drawing on Western models. Although this period of reform was very short lived, and came to a brutal end, it arguably paved the way for the later founding of the Republic, if only by proving that fundamental social change would never come from the top down.

Following the failure of the Hundred Days of Reform, Kang was forced into exile, staying in the West until the fall of the Qing dynasty. He wrote extensively, making important contributions to the study of calligraphy, of which he was himself a noted practitioner (Fig. 2.1). Given his personal interest in the practice of art, it is not surprising that he brought his reformist zeal to bear on it, arguing that Chinese painting would become extinct if it adhered to the old ways without change. Kang admired the painting of the Song dynasty (AD 960–1279), seeing in it an orientation towards reality which he felt was lost by later artists of the Ming (1368–1644) and Qing. Literati painting theory,

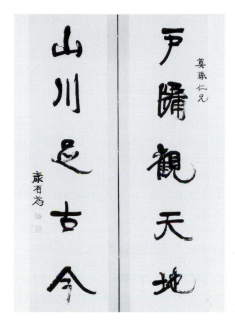

2.1 Kang Youwei, *Couplet in Running Script*. Date unknown. Reproduction by permission of the Provisional Urban Council, from the collection of the Hong Kong Museum of Art.

favouring as it did amateur expression of mood over the representational skills of the professional painter, was blamed by Kang for this decline. European painting, which he felt was based on the same principles as earlier Chinese art, was seen as a resource for reform, and Kang called for a new era in which Chinese and Western art were combined.

Amongst the artists to be influenced by Kang's ideas was Xu Beihong (1895–1953), who met him in Shanghai when still a young man. Persuaded by the idea that a rebirth of Chinese painting would come from an engagement with the more reality-oriented art of Europe, Xu travelled to France in 1919 on a government scholarship so that he could further his artistic education. Paris in the period immediately

following the First World War was of course a hotbed of modernist ideas, but Xu showed no interest in them. Instead, he provided himself with what was by French standards a very conservative training, with the aim of acquiring the skills in realistic representation which were lacking in the Chinese context.

At the Académie Julian, at the École Nationale Supérieure des Beaux-Arts, and from the painter Pascal-Adolphe-Jean Dagnan-Bouveret, Xu learnt how to work from life. He also came to appreciate the multi-figured thematic canvases of Jacques-Louis David and the nineteenth-century French academic and realist painters, many examples of which he was able to see at first hand in the Louvre. Drawing was the primary skill he needed to acquire, and surviving works from the time of his first European trip (he also spent a period of time in Berlin) show a high level of competence. They demonstrate an understanding of anatomical structure of a kind not found in earlier Chinese art, and they show an articulate use of shading to create a sense of fully rounded volume (Fig. 2.2). Xu acquired a similar degree of skill in oil painting, and in 1923 he succeeded in having an oil accepted in one of the Paris salon exhibitions.

Once back in his home country, Xu attempted to use his newly found skills to create paintings with Chinese subject-matter. Although he tended to avoid modern themes, Xu was nevertheless capable of producing works which contained contemporary allusions. The artistic language he had acquired in Europe was one developed to make public statements, and Xu's aspiration seems to have been to give painting a public role comparable to what it enjoyed in the West. Amongst his most ambitious works was *Tian Heng and His 500 Retainers* (1928–30)(Plate 5), begun not long after his return from a second trip to Europe.

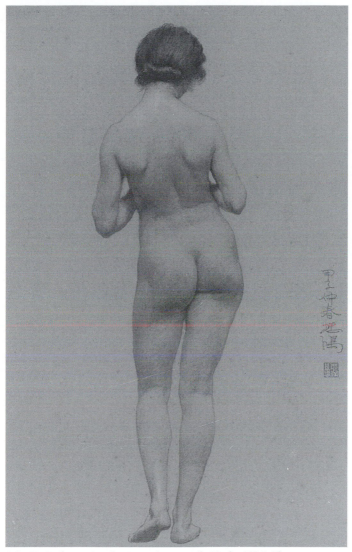

2.2 Xu Beihong, *Back View of a Female Nude*. 1924. Photo Courtesy Xu Beihong Memorial Museum, Beijing.

Tian Heng was based on the classical account of a figure who had taken part in a rebellion against the tyranny of the Qin dynasty (221–207 BC), but who refused to capitulate to the authority of the victorious Han Gaozu, founder of the Han dynasty (206 BC–AD 220). Tian Heng is shown taking leave of his band of followers before answering a summons from the new emperor. Just before arriving at the capital he is to commit suicide, arranging for his head to be presented to Han Gaozu as a sign of his unwillingness to yield and of his desire to save his followers. This image of heroic sacrifice is comparable in theme to David's *Oath of the Horatii*, perhaps, but it lacks that French work's dramatic unity. Xu's skill at representing individual figures is not supplemented in this large-scale, multi-figure painting by an ability to create believable compositions.

The influence of Kang Youwei was also felt by Liu Haisu (1896–1994), another of the prominent modernizers of Chinese painting in the early part of the century. Liu, too, looked to Western models for inspiration, but in comparison to Xu he proved more willing to accept aspects of early modernist art, in particular that of the Impressionists and Post-Impressionists. Traces of Paul Gauguin's Tahitian works, for instance, can be found in an oil of two Balinese girls from 1940, whilst Claude Monet's choice of subject-matter is recalled by paintings of the façade of Notre Dame cathedral in Paris (1930), and of the Houses of Parliament in London (1935). Liu's palette, under the influence of these less academic sources, is more colourful than that of Xu, who retained an essentially tonal vision.

Liu's touch is also more emphatic and visible, drawing attention to the painting surface where Xu might emphasize volume and mass. In a 1964 view of the Shanghai Bund, *Prosperous Shanghai* (Plate 6), the treatment—particularly

in the area of the sky—reminds us of the thickly applied brushwork of Vincent Van Gogh, who seems to have been a particular favorite of Liu. Indeed, Liu's invocation of the Dutch master seems somewhat overt in *Prosperous Shanghai*, and one cannot help but read the work as an essay in the manner of Van Gogh, rather than as a work inspired by that artist's vision of reality. Liu had been interested in painting cityscapes since at least the 1920s (when he produced an oil depicting Beijing's Qianmen), but the viewpoint he adopts on the Shanghai waterfront is hardly a novel one. Although he is able to indicate the industry and maritime trade which give the city its life, the image is not particularly well-composed. It lacks either a firmly established foreground or the dramatic absence of one which Monet sometimes uses to great effect.

Liu's best works are landscapes, whereas Xu usually did better when focusing on the human figure. Nevertheless, Liu is probably best known for his role in helping to establish the use of the nude model in Chinese art education. He had set up an art school in Shanghai while still quite young and lacking in personal exposure to Western art, and a life class was an important feature of its teaching programme. Liu was not the first art educator in China to employ the nude, but he became the most notorious when the use of nude models at the Shanghai Art Academy (as his school was later called) was attacked by the warlord Sun Chuanfang in the mid-1920s. Liu courageously defended the practice in a newspaper debate, and the use of models continued.

This public wrangle, and others of a similar nature, indicate the radical nature of the new art being created, as well as its increasing public impact. The human figure had never been as central in literati painting as it was in Western art, and to represent it with a sense of palpable physicality

21

as Xu was doing was altogether new. The life class was an institutionalizing of the importance of the human figure, as well as of the need for artists to study directly from nature. Inevitably the example of the art of the past—previously so crucial in Chinese art—became less central in such a model of art education. The methods of study used by earlier Chinese art, as much as its styles and subjects, were being abandoned. With the educational system proving such a force for change in art (as indeed in many other fields), it is not surprising that Liu, Xu, and other pioneering modernists such as Lin Fengmian (1900–91), were to devote so much of their efforts to the task of teaching.

Engagement with Western art was to become increasingly widespread as the Republican period progressed, and experimentation with a variety of later trends in European modernist painting was particularly to be seen amongst artists based in Shanghai. Access to Western culture was especially easy in that city as a result of the presence of foreign settlements, and a sophisticated, open, and culturally pluralist environment existed on a scale unmatched in any other Chinese city. Art magazines provided a space for debates about the new Western-inspired art which was emerging, as well as offering information about developments in Europe itself. A translation of André Breton's 1924 Surrealist Manifesto, for instance, was included in a 1935 issue of the periodical *Yi Feng* (Art wind). At the same time, an increasing number of exhibitions created opportunities for the new art to reach an audience, indeed to create for itself a public of a kind that high art in China had never before enjoyed. The government itself was to sponsor a National Art Exhibition, held in Shanghai in 1929, in which both realist and more modernist works were included, as well as ink paintings of various kinds. This exhibition was

to provide Xu with the opportunity to speak out against the influence of Western modernists such as Matisse and Paul Cézanne, and his views were hotly contested in turn.

Amongst the most radical supporters of an art based on Western modernist models were the members of the *Juelan she* (Storm society), founded in 1931. Prominent roles in this group were played by Ni Yide (1901–70) and Pang Xunqin (1906–85), the latter, Paris-trained artist proving the most modernistic in style. Pang's paintings of the early 1930s, whilst not directly mimicking European models, nevertheless show an engagement with early Cubism in their representation of human figures by means of simple forms (Fig. 2.3). Such a rejection or critique of realist methods was already implicit in Post-Impressionism but, despite his interest in it, Liu never approached the degree of stylization to be found in Pang's work.

There was widespread adoption of Western artistic languages and media in pre-Communist China, but nevertheless the works' success was on the whole limited, and a great deal of the art produced was experimental at best. In many cases artists did not have a sufficiently deep grounding in the techniques of European art to enable them to do work of a high level, and (particularly in the case of those who were attempting to use modernist styles) a distance from the context in which the art which inspired them had been produced made its meaning difficult to comprehend. Artists who had the chance to travel to the West were of course less likely to confront such problems, but on returning they still faced the difficult task of adapting what they had learnt there to the Chinese context, of producing works with specifically Chinese meanings. The discussion of Xu and Liu will have demonstrated that even those artists were not altogether successful in this regard,

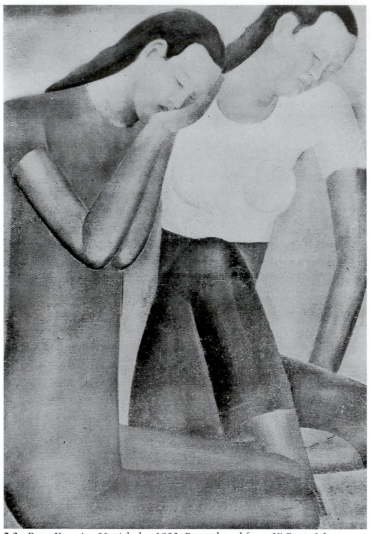

2.3 Pang Xunqin, *Untitled*. *c*.1933. Reproduced from *Yi Feng*, 1 June 1934, p. 75. Present whereabouts unknown.

and the fact that both artists produced ink paintings as well as oil paintings in the years after their return suggests a lack of willingness to commit completely to the Western-inspired artistic languages they had made so much effort to develop.

Factors beyond the control of the artists themselves also ensured that the success of Western-influenced art in early twentieth century China was only partial. Despite the growing popularity of art exhibitions, and the development of the art school system (in which Xu and Liu played important roles), the infrastructure for the new art remained somewhat weak. In a situation where the artists were summoning a new audience into being—given that literati art had never really circulated in public spaces—it was hardly surprising if their endeavors elicited a degree of incomprehension or indifference.

With time, a specifically Chinese brand of art inspired by Western modernism might well have developed and thrived in a city as cosmopolitan as Shanghai, but political and social upheaval did not permit. Just as the thriving modernist art of Russia had been suppressed during Stalin's regime, so its more fragile Chinese counterpart was to disappear after the success of the Communist revolution and creation of the People's Republic of China (PRC), if it was not already destroyed in the protracted period of war which preceded the 1949 victory. More realist modes of the kind Xu had been propounding were to survive, however, proving of use to the public art of the new, revolutionary social order. It was some time before consciously modernist experiments with Western inspiration were again to be seen in Chinese art, and when they emerged—this time with more success—it was to be in Hong Kong, Taiwan, and overseas, rather than in the People's Republic.

There is one exception to this rather pessimistic story of the early twentieth century Chinese engagement with Western art, and that is the case of Lin Fengmian. Along with Xu and Liu one of the pioneers in exploring the possibilities of Western artistic styles for Chinese art, Lin was ultimately to have the greatest artistic success of the three. He was more willing to utilize Western modernism as a resource than was either of those artists, and he seems to have successfully transmitted his personal interests to the students he taught at the Hangzhou Academy of Art during the 1930s and 1940s, since several went on to play significant roles in the revival of Chinese modernism.

Lin arrived in France is 1920, thereby gaining firsthand exposure to European art at an earlier age than did either Xu or Liu. He studied at art schools in both Dijon and Paris, later spending time in Germany as well before returning to China in 1926. Like Xu, he attained a sufficient level of competence in his adopted manner whilst still in Europe to have paintings shown in one of the French salon exhibitions (the Salon d'Automne). Perhaps the most ambitious in content of Lin's European-made paintings was *Groping* (1924) (Fig. 2.4), a group portrait of European intellectuals from various ages, including figures such as Dante and Tolstoy. Lin seems to have intended that no longer extant work to represent humanity's struggle towards civilization, and the role which the arts can play in it.

Groping was exhibited in Europe, and also in a show of Lin's works held in Beijing on his return to China. Whilst it might have been rather too overtly Western-oriented in its choice of cultural heroes to be well-received in a Chinese context, Lin did go on (as had Xu) to use his European pictorial language in executing works which addressed Chinese events and issues. This seems to be the case, for instance, with

26

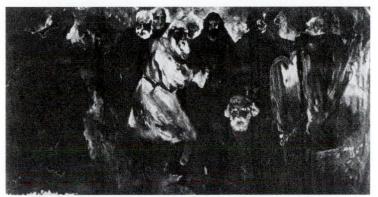

2.4 Lin Fengmian, *Groping*. 1924. Reproduced from *The Eastern Miscellany*, Vol. 21, No. 16, 1924. Presumed destroyed.

Suffering (1929), in which he used the eminently European theme of the nude to offer his comments on the tragic situation of contemporary China. *Suffering* was destroyed during the war of resistance against Japan, and so like many of Lin's earlier works it is only known to us through black and white reproductions surviving from the time.

In his belief that art could play a public, socially reformist role, Lin was indebted to the intellectual Cai Yuanpei, one of the major figures in China's attempts at cultural self-renewal during the Republican period. This intellectual revolution took place largely between 1917 and 1923, in the period often referred to as the New Culture Movement, and was given an important impetus by student demonstrations in Beijing on 4 May 1919. More far-reaching than was the reform movement of 1898, it led for instance to a simplification of the Chinese language (at the instigation of American-trained Hu Shi), which effected a profound break with classical culture. Chen Duxiu, responsible for founding the magazine *Xin Qingnian* (New youth), called on young people to overthrow stagnant

traditions in order that a new society might come into being. Whereas Hu was a pragmatist, looking for piecemeal change, Chen was more of a radical, becoming one of the founders of the Chinese Communist Party in 1921. Cai, who had studied in Germany as well as spending time in France, became chancellor of Beijing University in 1916, turning what had been a conservative institution into a powerhouse of the country's intellectual life.

Cai, who purchased several cubist paintings whilst in Europe and even met Pablo Picasso, evidently took a personal interest in the new art being produced there. He gave an important place to art in his vision of reform, believing that art education could take over the role formerly played by religion in the spiritual life of the people. This idea appealed to Lin, who suggests something similar in an essay he published soon after his return to China. Lin's travel to France had been facilitated by a scheme Cai had helped to found, and the two were to meet up on a couple of occasions during Lin's stay in Europe. On his return, Lin participated in Cai's project of educational reform, accepting first a post as principal of the Beijing Academy of Art, and then from 1927 the founding headship of the Hangzhou Academy of Art.

Like Xu and Liu, Lin had only limited success in his project of creating a Chinese public (or national) art utilizing means derived from European art. The experiences of the anti-Japanese war of resistance, and the civil war between the Nationalists and Communists which followed it, seemed to put an end to his efforts in this direction, and his later work was more personal in tenor. Although a public art most certainly did thrive in China after the establishment of the People's Republic, Lin found himself out of tune with the times, and his more subjective works were to get him into

trouble during the Cultural Revolution (1966–76). Only after settling in Hong Kong in 1977 was he free to paint without hindrance.

Most of Lin's later works may at first glance appear more Chinese in flavour than do either *Groping* or *Suffering*, but rather than retreating to tradition Lin was in fact producing a novel syncretic art. By moving towards a more subjective idiom, Lin was able to make more extensive use of both the Chinese ink painting heritage *and* what he had learnt about Western modernism. Colour, often intense and non-naturalistic, plays an important role in his later works. Usually it is in the service of expressive goals, but it also helps to create light effects. In his still lifes, for instance, black often represents light, as it does in the work of Matisse, an artist Lin clearly admired. In their abstracted and two-dimensional style, his still lifes strongly recall those of that French artist (Plate 7). His paintings of the female nude, also stylized and lacking in modelling, recall both Matisse and Amedeo Modigliani, but the features of his sitters are noticeably sinicized, thus preventing too Western a feel (Plate 8).

Lin's later essays in the genre of the nude can be compared to his use of the same theme in *Suffering*, in order to allow us to measure the distance he has travelled. In place of an ambitious multi-figured work, and a reference to a troubling social reality, we now tend to have a single figure and an explicitly private setting. A note of intimacy is introduced, and even a lightly stated erotic tone: only the artist (or spectator) is now witness to the depicted figure's nudity.

Many of Lin's later works are landscapes (Plate 9), and there is when he has worked in this genre inevitably a degree of allusion to the brush painting tradition for which it was such a central subject. Nevertheless, many features of his

landscapes are Western-inspired, such as the almost Impressionist interest in reflections on a water surface seen in certain cases. A strong emotional tone tends to dominate in his landscapes, which can often be described as melancholic, in contrast to the more positive feel of his still lifes and nudes. The skies can seem more heavily laden with dark clouds than is usually the case in earlier Chinese landscape paintings, and there is rarely a comforting indication of a human presence.

In terms of style as well Lin's landscapes differ from those of earlier Chinese artists. There are often strongly stated horizontal lines, and indeed they sometimes structure his whole composition. In addition, Lin tended to favour a square format more characteristic of European than Chinese practice. Because he commonly utilized water-based media in his later works, Lin found it easier than would an oil painter to combine effects from Western and Chinese art. Sometimes he would use the absorbency of his paper surface to create effects which are a familiar part of the vocabulary of ink painting, whilst on other occasions he abandoned the characteristic lucidity of Chinese art—the feeling one gets of being able to see each mark that was made—in favour of exploring the possibilities of opacity offered by gouache. In a way entirely familiar in European art, Lin would build his images up in layers, one layer partially cancelling an earlier one. Spatial ambiguity is often introduced in this way, with a clearly more recent layer perhaps being used to represent an area that is further away in pictorial space.

3

Art and Politics

THE STARK SOCIAL INEQUALITIES of the Republican period, as well as increasing political turmoil and fragmentation, naturally led some to seek radical solutions to China's problems. More culturally conceived models of national rejuvenation were eventually to give way to explicitly socio-political ones, leading in 1949, after years of resistance against Japanese imperialism (followed in turn by civil war), to the establishment of the People's Republic. Prominent amongst the artists of the 1930s and 1940s who believed most wholeheartedly in the necessity of a socially critical role for the visual image were those using the woodcut as a medium. Chosen for the ease with which it could be reproduced, and therefore the potential it had of enabling art to reach a mass audience, it was to become particularly popular with younger artists during this period.

Lu Xun (1881–1936), the most significant Chinese writer of his age and an important social critic, was personally responsible for the promotion in China of the woodcut as an artistic tool. During the 1920s and 1930s he collected European prints and published volumes of reproductions. He even arranged a workshop in 1931 so that young artists could learn the necessary techniques. Although Lu Xun also admired the Chinese woodcut illustrations produced in the Ming and Qing dynasties, the modern Western printmakers, with their realistic and expressionistic styles, were to provide the most useful models. Li Hua (1907–94), for instance, made use of the expressionistic distortions of Käthe Kollwitz in *Arise* (1935), which also follows that German artist in its subject, recalling closely an image from her *Peasant War*

series of etchings (1903). More original in conception is his *Roar, China!* (*c.*1935)(Fig. 3.1), a direct exhortation to action in response to the country's contemporary situation.

The use of such Western modernist resources as German Expressionism became less prominent amongst left-wing artists after Mao Zedong gave his *Talks at the Yan'an Forum on Literature and Art* in 1942. Speaking in the capital of the Communist-held area, Mao propounded views which were to have immediate effect on the art being produced there, and which were to provide the guidelines for state policy in the whole of mainland China after 1949. Mao emphasized the need for art and literature to reach a wider audience, stating that it should serve the broad mass of the people, taking their political interests as its own. The question of artistic quality was addressed, but political considerations were deemed paramount. Raising standards was regarded as important (since art should help elevate the masses), but this was seen as something which could only occur after contact with a broader audience had been established. Mao's views may be taken as a critique of the New Culture Movement's artistic and literary production, emphasizing for the benefit of cultural workers from an urban background the different conditions being faced in the Communist base areas.

One response by woodcut artists to Mao's new anti-élitist cultural directives was an experimentation, on account of their ready acceptability to the peasantry, with folk art styles. Communist ideology was sometimes conveyed, for instance, by using the format of traditional New Year's prints. An idealized realism, however, was to become the dominant manner in the People's Republic, for paintings as well as for woodcuts. The style of Xu Beihong was one resource for this, but socialist realism, borrowed from the Soviet Union, was

3.1 Li Hua, *Roar, China! c.*1935. Reproduced from *Banhua Jicheng: Lu Xun cang zhongguo xiandai muke quanji* (Vol. 1), Jiangsu Ancient Books Publishing House, 1991, by permission of the publisher and the Lu Xun Memorial Museum, Shanghai.

also an inspiration, particularly in the early years. The critical dimension of early European realist artists such as Gustave Courbet was completely lost, with a consequent weakening of art's ability to engage powerfully with the contemporary world, even though explicitly modern subjects were to become common.

Because of the need to promote positive models of revolutionary behavior, figure painting gained a new centrality in Chinese art, but landscape continued to have a place, particularly for ink painters. *Oil City in the South* (1972) (Fig. 3.2) by Guan Shanyue (b. 1912), for example, shows ink landscape painting in the active service of Communist state ideology. Although nature is still present, the works of man (that is, the achievements of the new society) unabashedly dominate in this eulogy to industrial advancement.

A student of Lingnan School artist Gao Jianfu, Guan has carried Gao's interest in modern subject-matter and realism of manner to extremes which that painter would never have contemplated. In *Oil City in the South*, long and perfectly straight diagonal lines—not found in classical Chinese painting—are a dominant part of Guan's composition, helping to define space. Steam from the locomotive and from the industrial activities in the middle ground pointedly takes the place played by cloud in the landscapes of earlier artists. A rupture with the styles of the past is clear, and intentionally so: both the painting and the industry it describes are to be read as progressive.

Oil City in the South dates from the period of the Cultural Revolution, and images from that time are often the first to come to mind when the art of the People's Republic is being characterized. Not all earlier phases of Communist rule were quite so extreme, however, and consequently some art of quality was produced, particularly by ink painters. Prominent

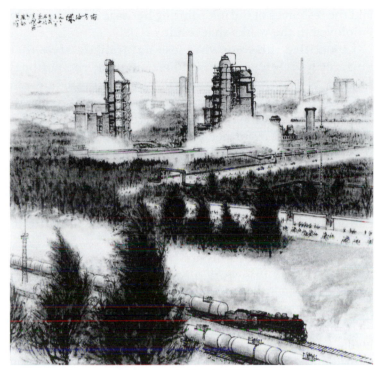

3.2 Guan Shanyue, *Oil City in the South*. 1972. Reproduced from *Guan Shanyue Huaji*, Guangdong People's Publishing House, 1979, by permission of the publisher and the artist.

amongst these was Li Keran (1907–89), who attempted in the early years of the PRC to create a realist mode of ink painting. Using his early exposure to Western painting methods as a resource, he moved away from allusion to the past, employing the Chinese brush to develop an art based more on observation. In 1959, he attacked slavish imitation, arguing that artists paint not only what they see but what they know. A parallel shift in his own practice is visible,

and the resources of the ink painting heritage are more richly employed in the works that result.

Li justified the somewhat less naturalistic style that emerges by reference to its subject-matter, the national landscape. Topographical specificity was not the norm in classical Chinese landscape painting, but Li tends to represent particular locations (sometimes of revolutionary significance) in his work. A further way in which a degree of freedom was negotiated was to make a painting based on a poem by Mao. This strategy was adopted by other mainland Chinese artists as well—indeed, the broader practice of introducing contemporary references into ink painting through calligraphic inscription is one used by many twentieth-century Chinese artists. *Ten Thousand Crimson Hills* (1964) is an example of a Li painting which alludes to lines from a Mao poem, and this work also introduces revolutionary associations by its extensive use of red paint (employed to describe the autumnal colours of maple trees).

Despite the efforts Li made to accommodate his art to state goals, he was nevertheless to run into trouble during the Cultural Revolution. Many of his landscapes from that time are stiff and unattractive. By contrast, Li's best landscapes (which often date from his late period) make extensive use of heavy black ink and keep concern for representation in balance with the desire for expression (Fig. 3.3). Evidence of his study of Western art can be found in these works (for example, in his treatment of light and shade), but its methods are more fully integrated with ink painting practice than in his earlier outline style. Monumentality seems to have been a quality Li aspired to in his landscapes, but a more informal, spontaneous manner can be seen in his many images of water buffaloes with their young handlers, works which appear to have been conceived as more private in nature.

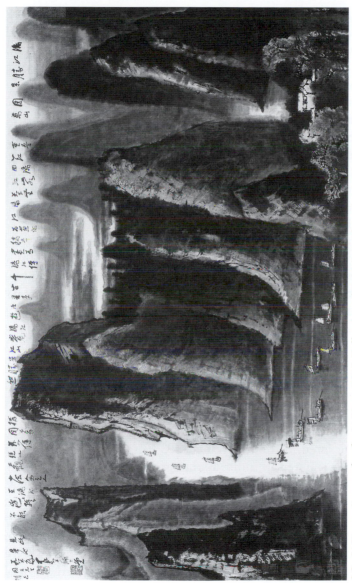

3.3 Li Keran, *Scenery by the Li River*. 1986. Collection of K. M. Lui. Photo courtesy the Hong Kong Museum of Art.

Another ink painter who proved capable of producing work of quality in the People's Republic was Fu Baoshi. Fu had developed his mature style by the 1940s (Plate 10), and although he did adapt to the new society by painting landscapes which alluded to its values, his best works retain a strong expressive flavour, making them a lot more subjective or individualistic in tone than most other art of the time (particularly oil painting) was allowed to be. His use of the brush remained very free, even when he was painting power lines or other subjects symbolic of progress or revolution, and he continued the exploration of textural effects which is a defining characteristic of his work.

Rather than using brushwork to define the external structure of depicted forms, give a indication of their mass through modelling, or simply offer information about their surface qualities, Fu instead often employed it to create a dynamic, open texture of an almost abstract nature. Dry brush gestures are one way in which Fu introduces both a sense of painterly texture and of linear energy, but commonly those gestural marks are combined with contrasting light and wet wash effects. A weightless feel is created, with only the occasional figure or two serving to tie things down more firmly to reality.

Fu died in 1965, before the Cultural Revolution began, so we will never know how his more personal art would have fared in that difficult time, but another ink painter who persisted in individual expression, Shi Lu (1919–82), was certainly to encounter problems. His earlier work was consciously revolutionary in style: *Fighting in Northern Shaanxi* (1959)(Fig. 3.4) illustrates a poem by Mao about the Long March and includes a portrait of the Chairman standing in thought on top of a cliff illuminated by a (Communist) red glow. Commissioned for the Museum of

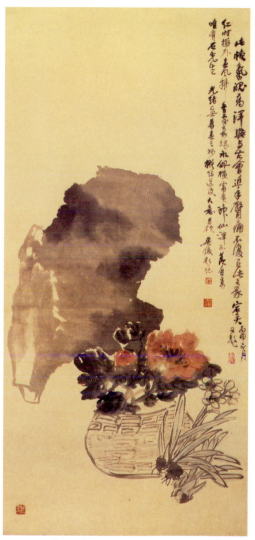

1. Wu Changshuo, *Peony, Narcissus, and Rock*. 1889. Collection of Helen and Peter Lin. Photo courtesy the Hong Kong Museum of Art.

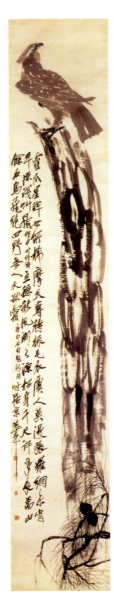

2. Qi Baishi, *Eagle and Pine Tree*. Not dated. M. K. Lau Collection, Hong Kong. Photo courtesy the Hong Kong Museum of Art.

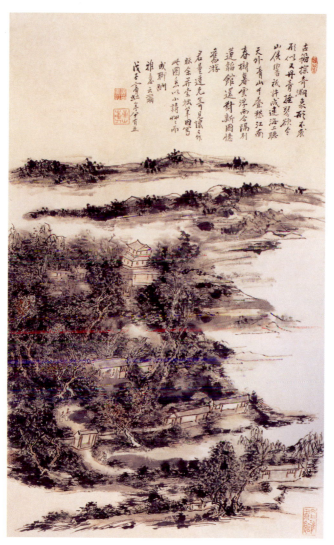

3. Huang Binhong, *Spring Trees in Jiangnan*. 1948.
Reproduction by permission of the Provisional Urban Council,
from the collection of the Hong Kong Museum of Art.

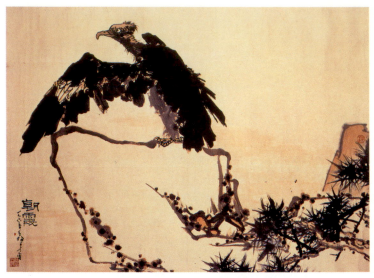

4. Pan Tianshou, *Morning Mist*. 1961. Private Collection. Photo courtesy the Hong Kong Museum of Art.

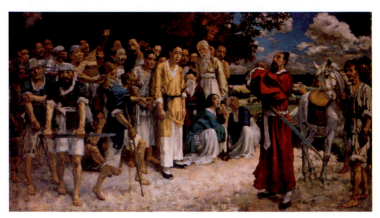

5. Xu Beihong, *Tian Heng and His 500 Retainers*. 1928–30. Photo Courtesy Xu Beihong Memorial Museum, Beijing.

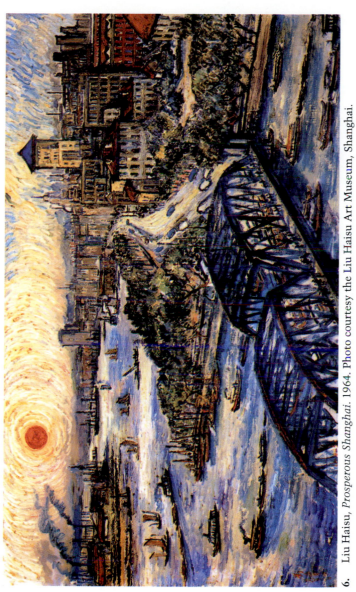

6. Liu Haisu, *Prosperous Shanghai*. 1964. Photo courtesy the Liu Haisu Art Museum, Shanghai.

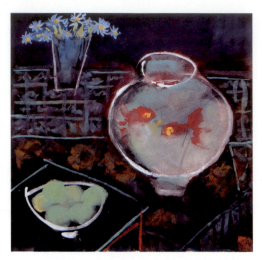

7. Lin Fengmian, *Still Life*. Late 1970s. Photo courtesy the Hong Kong Arts Centre.

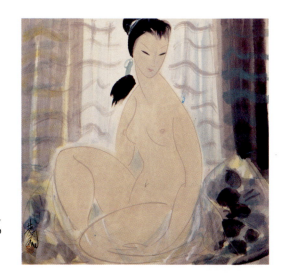

8. Lin Fengmian, *Figure*. 1980. Photo courtesy the Hong Kong Arts Centre.

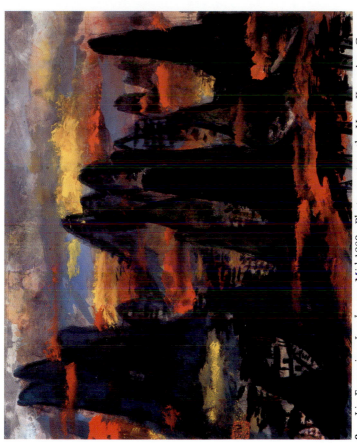

9. Lin Fengmian, *Landscape.* Mid-1980s. Photo courtesy the Hong Kong Arts Centre.

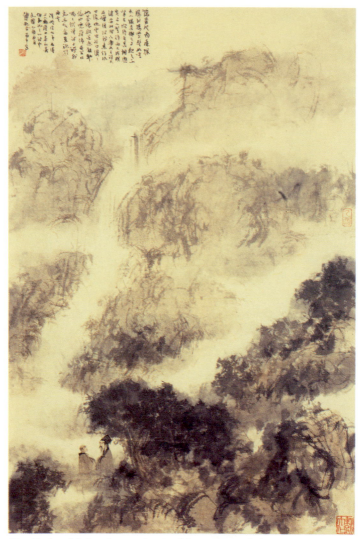

10. Fu Baoshi, *Landscape Inspired by a Poem of Shitao*. 1945.
Reproduction by permission of the Provisional Urban Council, from
the collection of the Hong Kong Museum of Art.

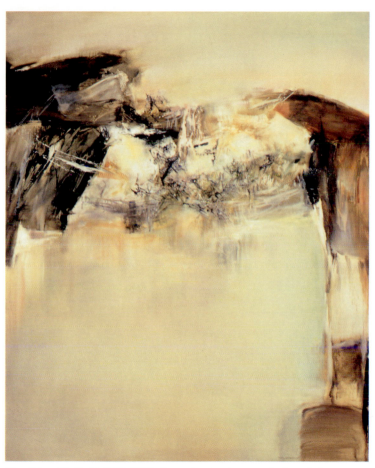

11. Zhao Wuji, *13-9-73*. 1973. Reproduction by permission of the
Provisional Urban Council, from the collection of the Hong Kong
Museum of Art.

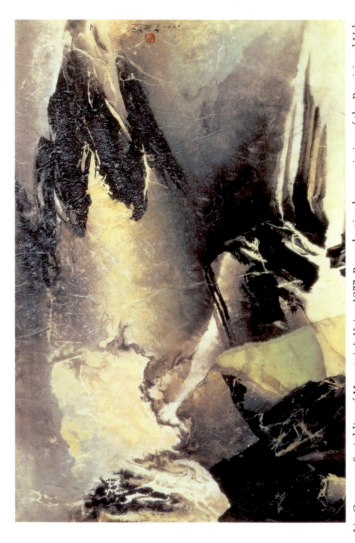

12. Liu Guosong, *Sprinkling of Mountain's Voice*. 1977. Reproduction by permission of the Provisional Urban Council, from the collection of the Hong Kong Museum of Art.

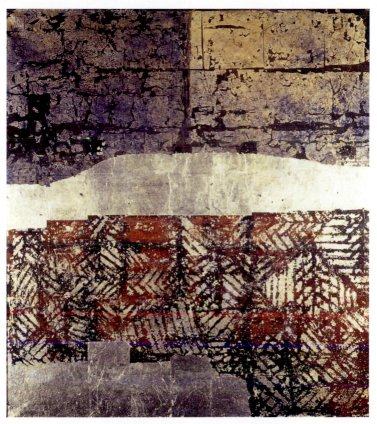

13. Zeng Youhe, *The Cragged*. 1971. Photo courtesy the artist.

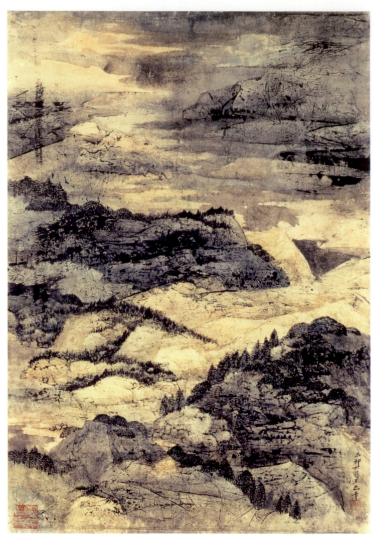

14. Wang Jiqian, *Landscape No. 333*. 1975. Reproduction by permission of the Provisional Urban Council, from the collection of the Hong Kong Museum of Art.

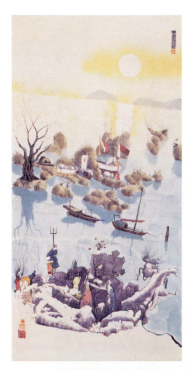

15. Chen Fushan, *Execution*. 1974.
Reproduction by permission of the
Provisional Urban Council, from the
collection of the Hong Kong
Museum of Art.

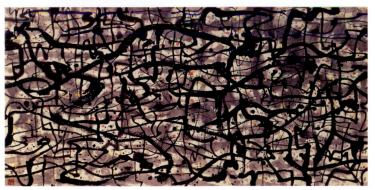

16. Wu Guanzhong, *Knots of Affection*. 1992. Collection of the artist.
Photo courtesy the Hong Kong Museum of Art.

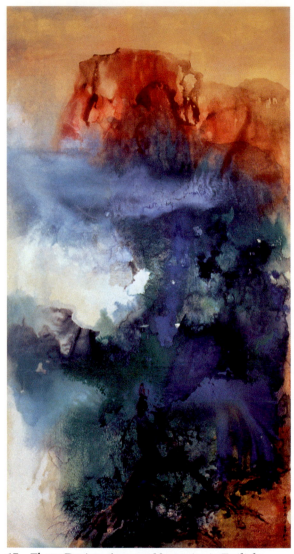

17. Zhang Daqian, *Autumn Mountains in Twilight*. 1967. The Mei Yun Tang Collection.

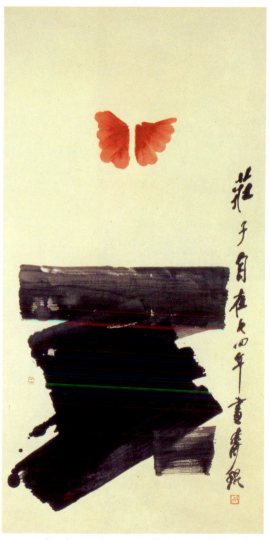

18. Lu Shoukun, *Zhuangzi*. 1974. Reproduction by permission of the Provisional Urban Council, from the collection of the Hong Kong Museum of Art.

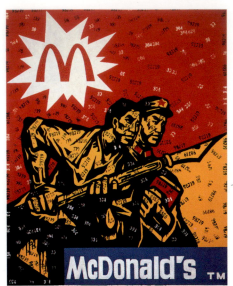

19. Wang Guangyi, *Great Criticism Series: McDonald's*. 1992. Photo courtesy Hanart TZ Gallery.

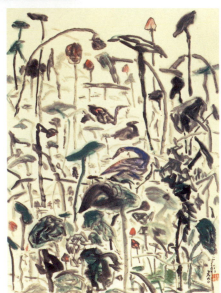

20. Yu Peng, *Lotus Pond*. 1990. Photo courtesy Hanart TZ Gallery.

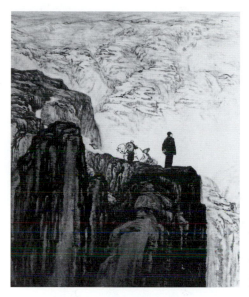

3.4 Shi Lu, *Fighting in Northern Shaanxi*. 1959. Photo courtesy the Museum of Chinese Revolutionary History, Beijing.

Chinese Revolutionary History in Beijing, it was an innovative attempt to treat historical narrative in a landscape format. His later work, however, particularly after his 1962 encounter with the work of the late Qing painter Xugu, becomes increasingly personal. Some of Shi Lu's political paintings had contained raw brush effects (justified by the artist as a deliberate departure from élitist literati elegance), but this tendency was to become more pronounced. An angular brushwork inspired by Xugu appears in certain works, and dark ink is often used. Greater abstraction becomes the norm as the artist charts a route towards a less public style (Fig. 3.5).

A desire for greater realism in art and for engagement with modern subjects had been common amongst Chinese artists of the earlier part of the twentieth century. In a sense this desire (along with others such as the wish for a broader

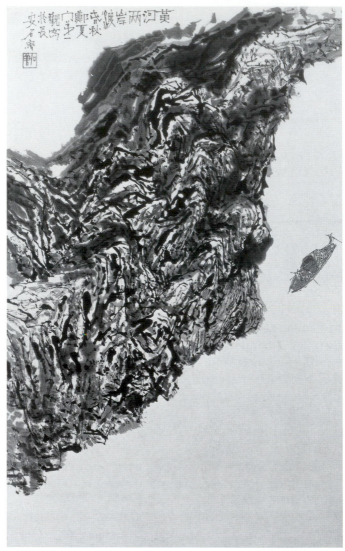

3.5 Shi Lu, *Yellow River Gorges. c.*1972. Private Collection. Photo courtesy the Hong Kong Museum of Art.

audience and an expanded public role) were met in the PRC, but at the same time centralized control inhibited creativity profoundly, in art as in other areas of life. An artist could now enjoy a secure income from the state (and might even aspire to a prestigious public commission), but would have to submit to restrictions of both theme and treatment. Art was now considered something of great social importance, but it was also subject to political restraint for that very reason.

As a consequence of the situation artists had to face in the PRC, much of the most innovative Chinese art of the post-war period was made outside the borders of the Communist state, in Hong Kong, Taiwan, and overseas. A great deal of what is valuable in twentieth-century Chinese art was created by artists who had an openness to the art of other cultures, and artists based in these locations were better placed (given Communist China's relative closure from 1949 until after the end of the Cultural Revolution) to respond to new developments in the art of Europe and North America.

4

The New Internationalism

IN THE PERIOD following the end of the Second World War, Western modernism began to take new directions. Arguably the most important artists of that time (and certainly the most internationally celebrated) were the American Abstract Expressionists. They, and those European artists who were their counterparts in terms of style, produced a kind of abstraction which differed considerably from that of the pre-war years. It was based not on geometric forms but on energetic gestural marks, either made by the freely handled brush or (in the case of Jackson Pollock) by directly pouring paint. This was an art in which the direct and the spontaneous was valued, in which the process of art-making became a part of its content.

Whereas earlier Western modernism had often been difficult for Chinese artists to make use of, this new tendency made the gap between Chinese and Western visual culture appear less wide. Western modernism seemed at that point to be emphasizing some of the very characteristics that were central to the inherited language of ink painting, such as the primacy of the spontaneous gestural mark. Indeed, as Chinese artists no doubt realized, certain of the Abstract Expressionists had been directly influenced by East Asian art and culture.

Many Chinese artists were inspired by the more gestural art being produced in the West, and a new wave of Chinese modernism was to appear—particularly in Hong Kong, Taiwan, and overseas, where access to information about the new Western art was more easy to come by. Whereas artists such as Gao Jianfu or Xu Beihong had turned to the

West for a resource to criticize the lack of realism they saw in ink painting, a later generation of artists was to find in this later Western modernism something compatible with inherited Chinese aesthetics, even if it inspired them to create art which was completely novel in appearance.

One of the most significant Chinese artists of this generation is Zhao Wuji (Zao Wou-ki, b. 1921), a former pupil of Lin Fengmian at Hangzhou who settled in Paris in 1948. Other Chinese artists may be taken as responding to a new emphasis on the spontaneous gesture in Western art, but Zhao was one of the artists actually responsible for creating that emphasis. More, perhaps, than any other ethnically Chinese artist, Zhao's work was produced within a Western cultural context, and it has rightfully found a place in Western art historical accounts. Although he has occasionally worked in ink since 1971, oil has always been Zhao's primary medium. When he engages in dialogue with the classical Chinese painting heritage, as he has done at certain points in his artistic development, the distinction of medium enables him to meet it on his own terms, and so avoid being overwhelmed by it. Using oil, he must perforce translate, not mimic.

Zhao's early works show an awareness of the art of Paul Klee: he was interested in cityscapes, for example, and in exploring textural effects. Around the middle of the 1950s, however, his works become both more abstract and more individual. A flatter space was introduced, and in certain works (such as *Wind*, from 1954) a vocabulary of linear forms arranged vertically suggest that a study of Chinese calligraphy proved crucial to his breakthrough. In works of the later 1950s, the calligraphic marks evolve into energetic gestural forms, entangled with each other in something between a dance and a battle.

Landscape associations, although never very direct, become more common in Zhao's works of the 1970s (such as 1973's *13-9-73*)(Plate 11). This addition enables a greater sense of space in the images, and sometimes Zhao seems to be renewing his dialogue with Chinese art. Despite hints of mountain and cloud, however, directly 'Chinese' references are avoided, and in the works which follow, landscape imagery becomes harder to find. Horizons and orientations to gravity become less distinct, and a concern with spatial voids becomes more pronounced. Natural forces rather than natural forms now seem to provide the subject-matter, conveyed through flows and splatters of paint more than through brushed marks, as if the canvas were an arena where the elements contend directly.

Although idealized realism became the dominant manner in the People's Republic, it is hardly surprising that art in Taiwan was often traditionalistic in nature. The Nationalist government, which had retreated to the island following the civil war, presented itself as the guardian of Chinese traditions, its possession of the imperial art collections helping to support its claim to legitimacy. Such an environment was not an altogether fertile one for the development of a modernist art but, partly because Taiwan was subject to American cultural influences, certain artists did respond to the new Western trends. Liu Guosong (Liu Kuo-sung, b. 1932) has been amongst the most adventurous of these, playing an important role in the modernist *Wuyue pai* (Fifth moon group), which held its first exhibition in May 1957.

Initially, Liu experimented with Western media and styles, but after seeing great early works of Chinese painting from the former imperial collection when it finally went back on public display in the early 1960s, he returned to using ink

and paper. The works he produced in the period which followed combined the gestural dynamism of Abstract Expressionism with aspects of the Chinese aesthetic heritage. Whilst readable first as compositions of energetic abstract marks, Liu's works generally evoke landscape associations on closer acquaintance, recalling in particular the mountains and clouds of classical Chinese painting (Plate 12). In terms of style, and not just of subject, there is a relationship with earlier Chinese art: Liu's careful employment of empty white areas as an active part of his composition is perhaps the most obvious example.

Clearly, there is an attempt by Liu to make his paintings consciously Chinese in flavour, but this should not blind us to the degree of technical experimentation taking place. At different times Liu has made use of collage, for instance, or of marbling techniques. He has been particularly interested in exploring the possibilities of texture, and one method he has made his own is the creation of jagged white linear effects by removing fibres from the already-painted surface of a course-fibred paper.

Other Chinese artists of this generation have also been responsible for technical experimentation, finding ways to bypass or supplement that most conventional of tools, the Chinese brush, whilst continuing to create images that retain contact with inherited Chinese aesthetic standpoints. Zeng Youhe (Tseng Yu-ho, b. 1923), based in Hawaii since 1949 and well acquainted with developments in Western modernist art, has experimented with collage techniques in order to produce abstracted landscapes with richly textured surfaces (Plate 13). The popularity of collage in earlier Western modernism no doubt helped to inspire Zeng's style, but her work is also related to Chinese and Japanese precedents in its use of paper or metal foil. Wang Jiqian

(C. C. Wang, b. 1907), who also moved to the United States in the late 1940s, settling in New York, parallels Liu's use of chance techniques to create surface texture, perhaps in imitation of Surrealist artists such as Max Ernst. Wang would dip a crumpled-up sheet of paper in ink, for instance, before applying it to another sheet to produce random linear marks, which could then be further elaborated (perhaps with a brush), eventually to become a Chinese-flavoured mountain landscape (Plate 14).

Hong Kong-based painter Chen Fushan (Luis Chan, 1905–95) also adopted a technique of random mark-making, which he had learnt from a visiting French printmaker. The method enabled him to escape the mimicry of Western modernist styles which had been plaguing him for several years, and tap into the creativity of his own unconscious. Like Wang, Chen would edit and develop the randomly produced marks, although in his case the results bore only a tenuous relation to classical Chinese art. He would discover faces and indeed a whole fantasy world in his chance beginnings. A plethora of references would emerge: Chinese or Western, high cultural or popular, but always deeply personal. *Execution* (1974)(Plate 15), like many of his works a landscape, is an example of his highly imaginative idiom.

Wu Guanzhong (b. 1919), perhaps the only Mainland artist to be part of this story, commonly adds splashed or dribbled marks to his paintings, sometimes relegating conventional brushed gestures to a relatively minor role. The all-over pattern of lines and dots which results can be reminiscent of Pollock's work in certain respects, although a concern for rhythmic vitality has also been long-standing in Chinese artistic theory, and Wu is alluding to this aesthetic context as well. Like other Chinese artists, Wu is reluctant to come too close to pure abstraction: ultimately the display of linear

energy has to have a descriptive excuse. *Knots of Affection* (1992)(Plate 16), for instance, seems to have a wisteria or other such climbing plant as its subject.

Having displayed his mastery of many earlier Chinese styles when younger, Zhang Daqian was to join the wave of artists turning to Abstract Expressionism for inspiration when he was already at a relatively advanced age. This development belongs to the period between the early 1950s and the mid-1970s, during which he lived first in South America and later in North America, as well as to his final Taiwanese phase. Large abstract fields of colour are floated across the surface of his increasingly freely executed paintings, but there are always some more carefully brushed details to give us confirmation that we are looking at a landscape (Plate 17).

Whereas many earlier reformers of Chinese art had been anxious to introduce modern subject-matter, most leading artists of this generation were more interested in a modernity of style. Individual expression now seemed to matter more than social commitment, and this may be one reason why subject-matter became less of a site of struggle for modernity. A move towards the abstractness of contemporaneous Western art perhaps made the whole issue of literal subject-matter less important, but as we have seen most artists were reluctant to go too far in this direction, and a concern for landscape, that most central of Chinese painting subjects, remained strong. In the case of certain artists the conservative choice of subject-matter may have been tied to the desire to retain a consciously 'Chinese' quality in works which were otherwise quite Western in language. Despite the affinities between Abstract Expressionism or European gestural abstraction and its Chinese counterparts, it seems that these artists still shared some of the problems that had been

encountered by earlier Chinese artists attempting to employ aspects of Western modernism.

On occasion, artists of this era would make use of subject-matter which was not found in earlier Chinese art, but which nevertheless was consciously 'Chinese'. Taiwanese sculptor Zhu Ming (Ju Ming, b. 1938), for example, is most well-known for his sculptures of figures engaged in the Chinese martial art of t'ai chi (*taiji*). Executed either in roughly carved wood, or else from Styrofoam cast in bronze, they offer a three-dimensional equivalent to the energy-filled gestures of the painters discussed here. Large masses—simplified representations of human limbs—are deployed in dynamic arrangements (as in *Taichi Single Whip*, 1985) (Fig. 4.1).

Because carvers had only craftsman status in earlier times, a modern Chinese sculptor has no easy recourse to subject-matter sanctioned by literati precedent in the way a painter has. The reference to t'ai chi is a clever solution to that problem, invoking Chinese cultural roots whilst enabling an art open to Western stylistic inspiration. Whereas we were able to document significant engagement with Western modernism by Chinese painters in the first half of the century, it is only in the second half (and then only in Taiwan and Hong Kong, at first) that we really see Chinese sculpture that is consciously modern in style. Because of the sheer expense of the materials involved in sculpture made of bronze or stone, it tends to be dependent on commissions, and thus must wait more than painting needs to for public taste to develop.

Zhuangzi (1974)(Plate 18), by Hong Kong painter Lu Shoukun, also has a subject which is both new to Chinese art yet strongly Chinese in flavour. It invokes the famous account by the philosopher Zhuangzi of a dream in which he was transformed into a butterfly. The work is very simple,

4.1 Zhu Ming, *Taichi Single Whip*. 1985. Photo by the author.

consisting of a group of broad calligraphic brush strokes in black surmounted by a smaller and more static red form in the shape of a butterfly. All are placed against a bare white background with a single vertical inscription to the right side. Gestural energy is imparted to the marks in the bottom half of this carefully balanced image by allowing certain areas within the strokes to escape the application of ink. An impression of speedy execution is also created by the drops of splashed ink to the bottom left.

Almost abstract, at least when compared to earlier Chinese art, *Zhuangzi* offers yet another example of a Chinese artist responding to the new developments in post-war Western art. The black brushstrokes recall the French abstract painter Pierre Soulages, for instance, whilst the compositional structure as a whole is strongly reminiscent of certain images by the American Abstract Expressionist Adolph Gottlieb. Lu seems to wish his work to have a recognizable relationship to then current modernist styles (thereby giving it international credibility), but at the same time to appear noticeably Chinese and connected to the Chinese ink painting heritage. As well as through the subject-matter, this national or traditional flavour is also produced at the level of technique by Lu's use of Chinese ink and paper.

In *Zhuangzi*, Lu balances the Western and the Chinese (or the modern and the traditional) with a great deal of success, managing to avoid seeming either a deracinated mimic on the one hand, or an outdated prisoner of tradition on the other. The dilemma that he and other would-be modern ink painters faced seems momentarily transcended. Wang Wuxie (Wucius Wong, b. 1936), however, seems to admit that dilemma, and even to dramatize it in the paintings themselves. This younger Hong Kong painter, who (like many other artists in Hong Kong) studied with Lu for a time,

also makes use of Western stylistic elements in his works, but he does not attempt to harmonize them with the 'Chinese' aspects. In *Cloud Harmony, No. 1* (1978) (Fig. 4.2), for example, he introduces a strongly stated geometric grid, which seems to cut up the very 'Chinese' misty mountain landscape behind.

Whereas Lu turns to those aspects of Western modernism which are most capable of being harmonized with Chinese art (because they share Chinese painting and calligraphy's concern with dynamic line), Wang looks to have deliberately favoured a geometric style in order to introduce a degree of contrast. The subject of *Cloud Harmony, No. 1* seems to be the clash of East and West: Wang appears to be looking for a compositional balance which will symbolically resolve the differences between these apparent opposites, whilst not denying either. In a city like Hong Kong, often referred to as a place where 'East meets West', it is not surprising if artists should feel caught between conflicting cultural influences: Wang responds by making such clashes a conscious theme of his work.

In recent decades, analysts of Western art have often used the term 'post-modernism' to describe art which consciously quotes or borrows from other visual images (whether of high art or popular cultural origin). Such art is intentionally hybrid in nature, often flaunting a mixed stylistic language, and differs from the more stylistically unified work of earlier Western modernists. The appearance of this tendency, which could be dated to the emergence of Pop art in the early 1960s, was in due course to have consequences for Chinese art. Abstract Expressionism, for a long time a resource for modernity in Chinese art, eventually began to seem passé, and new strategies of producing art with a contemporary feel were explored. Artworks which made ironic reference to

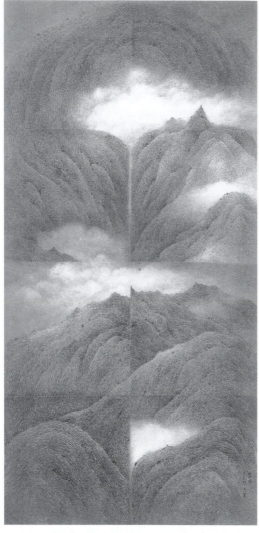

4.2. Wang Wuxie, *Cloud Harmony, No. 1*. 1978. Reproduction by permission of the Provisional Urban Council, from the collection of the Hong Kong Museum of Art.

earlier images began to appear in China as well, for instance, but (as the discussion of Wang's *Cloud Harmony No. 1* will have demonstrated) the hybridity associated with post-modernity in the West was already present in the modern phase of Chinese art.

Indeed that hybrid quality was often strongly marked, because it was cultural and not simply stylistic. The distinction between modern and post-modern art in the Chinese context (to the extent that such categories are useful at all) is that post-modern artworks exploit or accept hybridity, whereas modern artworks are more concerned to somehow manage the traces of stylistic difference (as in the case of Wang), or simply to erase our awareness of them (as in the case of Lu).

Of the artists discussed here the one who comes closest to this post-modern attitude is Chen Fushan. A well-read but self-taught artist who hardly ever left Hong Kong, Chen appears in his mature phase, which came quite late in life, to have transcended worries over whether his art was 'modern' enough (on the one hand) or 'Chinese' enough (on the other). Doubly marginal, and acutely aware of his situation as perhaps only an artist living under colonialism could be, Chen was forced back on his own mental resources. By giving a significant role to the unconscious in his working process he was able to create artworks which playfully incorporated imagery from a broad variety of origins. Both China and the West were raided by Chen for materials with which to construct his own rich universe.

5

Towards a Pluralistic Future

THE CULTURAL REVOLUTION came to an end in 1976 with the death of Mao and the arrest of the Gang of Four. In the era which followed, the economic was given priority over the political, and a comprehensive programme of modernization was initiated under the leadership of Deng Xiaoping. Capitalism returned to mainland China as a result, and the opening of the country to foreign trade and investment inevitably led to a dramatically increased exposure to Western intellectual and cultural life. Although limits to freedom of expression remained significant, new developments in Chinese art were almost inevitable.

One of the first real signs that things had changed was the Beijing 'Democracy Wall', where critical ideas could be expressed on posters. In the brief period from 1978 to 1979, during which the authorities permitted the existence of this forum, it offered an unprecedented public outlet for dissenting voices: *Jintian* (Today), an unofficial literary journal founded by the poet Bei Dao, was displayed in the form of a wall poster, for instance, and Wei Jingsheng used the site to make his well-known call for democracy in China.

The visual artists most closely associated with this growth of unofficial culture were the members of the short-lived *XingXing* (Stars) group, who in September 1979 displayed their artworks without permission on railings adjoining the China Art Gallery. When eventually forced to remove them, they staged a protest march to the offices of the Beijing Municipal Party Committee, and then to the Democracy Wall. Perhaps surprisingly, they were given an official opportunity to exhibit their work during November and

December 1979, and again in August 1980. The Stars artists lacked formal training, and because of the closure of China during the preceding decades their knowledge of Western modernist art and its supporting discourse was extremely superficial. Arguably the most interesting artist of the group was the sculptor Wang Keping (b. 1949), who produced wood carvings with a critical political content. His *Silence* (1978), for instance, is a plea for freedom of expression, taking the form of a head with a plug in its mouth and tape across one of its eyes. *Idol* (1978) (Fig. 5.1)—another head—clearly represents Mao and can be taken as a comment on the personality cult of the Chairman which had developed during the Cultural Revolution.

Although executed in a realist manner, *Father* (1980) (Fig. 5.2), an oil painting by Luo Zhongli (b. 1948), differs significantly from the dominant official style of the preceding period. In place of the idealization of peasant life so common in earlier art of the People's Republic, we are offered a very detailed representation of a face bearing all the traces of a life spent in hard manual labour. Luo's own experiences of living amongst peasants during the Cultural Revolution lie behind *Father*, but so does the photo-realist art of the American Chuck Close, an example of which he saw reproduced in a Chinese art periodical. It is from this latter source that the work gets its large scale (241 cm by 160 cm) and its use of extreme close-up. A ball-point pen behind the old man's ear was apparently a late addition made on the insistence of the chairman of the Sichuan Artists Association: the work as it stood was lacking in revolutionary optimism, and an indication of literacy was felt necessary to introduce a more positive note.

By the late 1980s, a relatively mature avant-garde culture had come into existence on the Mainland. As a result of

5.1 Wang Keping, *Idol*. 1978. Photo courtesy the artist.

5.2 Luo Zhongli, *Father*. 1980. Reproduced by permission of the artist and the Zhejiang People's Fine Arts Publishing House.

China's new openness more deeply aware of overseas developments than were the members of the Stars group, the best of these artists nevertheless made art which addressed culturally specific concerns. Xu Bing (b. 1955), who trained as a printmaker, has gone on to produce installation pieces that draw on his technical skills, but which show awareness of Conceptual art, in their cognitive complexity, and Dada, in their nihilism. His best-known piece is *A Book from the Sky* (Fig. 5.3), which was shown at the China Art Gallery, Beijing, in October 1988, as well as in a ground-breaking exhibition of Chinese avant-garde art (opened on 5 February 1989) held at the same location.

In making this work, the artist carved thousands of Chinese characters onto wooden blocks, and then printed them on paper in a manner familiar from old books. Tradition

5.3 Xu Bing, *A Book from the Sky* (detail). 1988. Photo courtesy the artist.

is strongly invoked by *A Book from the Sky*, but at the same time it is denied or negated, since each of the Chinese characters he has carved is entirely without meaning. Each has the recognizable structure of a real character, but the artist has taken care to ensure that none may be found in a dictionary. The work as a whole is saturated with the flavour of Chinese written culture, yet there is nothing within it that someone capable of reading Chinese can firmly grasp, resulting in a profound disorientation. A kind of solemn and purposely long-winded joke (the work took about three years to complete), it subverts the authority of the past by means of a careful attention to it.

Whereas Xu wishes with his *A Book from the Sky* to confront and empty out the Chinese cultural heritage as a whole (perhaps searching for a place to make a new beginning free from its weight), several other Chinese avant-garde artists make the restricted visual language of the Cultural Revolution era their target, particularly in the period following the suppression of the Democracy Movement in 1989. Using parody as their means, they invoke that no longer dominant code in order to move beyond its closures. Mao Zedong (as represented in certain well-known images) appears in the work of several artists, including Li Shan (b. 1944), Yu Youhan (b. 1943) (Fig. 5.4), and Wang Guangyi (b. 1956). Each of these three adopts a bold and colourful style openly indebted to American Pop art, which is itself concerned with recycling previously existing imagery of a widely disseminated nature.

By making references to Pop art (even images of Mao can remind us of the work of Andy Warhol), these 'political pop' artists are able to address an international audience, a matter of some importance since there is as yet little development of a market for art of this kind at home. Because many

5.4 Yu Youhan, *Double Image*. 1992. Photo courtesy Hanart TZ Gallery.

Western artists in the 1980s relied on the appropriation of imagery, their use of this same strategy makes the Chinese artists seem 'up to date' for Western viewers. Nevertheless, such images as Wang Guangyi's *Great Criticism Series: McDonald's* (1992)(Plate 19) are primarily concerned with commenting on issues specific to the time and place of their creation. By combining references to the visual rhetoric of the Cultural Revolution with images drawn from Western consumer advertising in this openly hybrid work, Wang is specifying the moment when capitalist consumer culture entered a Communist China (McDonald's opened its first Beijing outlet the same year that Wang painted this work). He presents his 'hot' content in a coolly deadpan manner, choosing neither to celebrate nor to openly attack. The very lack of a clearly stated position is somewhat subversive: the old (Communist) celebration of production and the new (capitalist) celebration of consumption are simply juxtaposed without comment, despite the contradictions between them.

Artists utilizing Western media were responsible for a great deal of the more interesting work being produced in the People's Republic during the later 1980s and the 1990s, and the same can be said of Hong Kong. Although ink painters such as Lu Shoukun had been responsible for producing the first consciously modernist art in Hong Kong, the emphasis was to change as more Western-trained artists returned to the territory in the 1980s. A demographic shift was occurring: the older generation, a great many of whom had arrived as refugees from Communist China, naturally had allegiances to brush and ink, but the younger generation, growing up in a city now closed off from the rest of China, were more likely to look to the West in their search for an artistic language.

Hong Kong artists of this younger generation, whilst not devoid of a sense of being Chinese, have tended much more

than did their parents to take the city itself as their cultural frame of reference. In the years following the 1984 Joint Declaration agreeing on Hong Kong's return to China (and particularly after the political confrontations in Beijing surrounding 4 June 1989), a number of Hong Kong artists became actively concerned with the question of Hong Kong cultural identity. No doubt a phenomenon inspired by the impending 1997 re-absorption into China—an assertion of selfhood at the very point when autonomy seemed most threatened—it has led to art critical of nationalist rhetoric and explicitly local in its reference (even whilst cosmopolitan in its language).

Stories Around Town, for example, a series of graphic works created from 1991 onwards by He Qingji (Oscar Ho Hing-kay, b. 1956), depict contemporary and historic events in Hong Kong life. Some works in the series produced around the time of the 1997 return of Hong Kong to China are fairly direct critical comments on actual events, but most images have a strong fantasy dimension, sometimes drawing on existing urban myths as a way to highlight current local anxieties. Although different in style, a model for He's *Stories Around Town* can be found in the late Qing pictorial magazines which reproduced lithographic illustrations with commentaries, often presenting bizarre tales of dubious authenticity. This source is drawn on by He for the inscriptions he makes on his own works, such as *Haunting Images at Yuk Wo* (1991)(Fig. 5.5).

Art in Taiwan during the 1990s has displayed some of the same local emphasis as has that of Hong Kong, and again the employment of Western styles and media has been a major feature. Even the work of an artist so clearly inspired by the history of Chinese ink painting as Yu Peng (b. 1955) shows awareness of Western approaches to image-making.

5.5 He Qingji, *Haunting Images at Yuk Wo*. 1991. Photo courtesy the artist.

For instance, he often flattens out pictorial space in his landscapes in a way that recalls European modernism, and his brushwork can look very rough and unrefined if judged in accordance with more traditionalistic Chinese standards (Plate 20). Yu's relation to the Chinese painting heritage is so self-conscious that one might want to refer to his work as 'post-modern ink painting'. Earlier Chinese art remains fully available to contemporary artists as a potential resource, but it is no longer possible for artists to present their work as an unproblematic continuation of literati practice. When an artist adopts a literati identity, as does Yu, it must be donned like an exotic masquerade costume.

With their marked engagement with the international world, the contemporary artists of Hong Kong and Taiwan are in many ways at the developing edge of Chinese visual culture, which (as we have seen in these pages) has so often in the twentieth century grown more from the margins than from the centre. Although artists in the People's Republic are benefiting from their country's increasing openness, with a growing number finding opportunities to exhibit, travel, or live overseas, the absence of a real freedom of expression within China itself is still a major obstacle to artistic development. So far, the evolution of a truly vibrant contemporary art scene has been prevented by government policy, desirous as it is of preserving a particular national culture even as it attempts to extend China's participation in the global economic marketplace.

Fear of the foreign is a common phenomenon, but the history of twentieth-century Chinese art demonstrates than whilst it is not always easy to make use of that which originates elsewhere, it is frequently valuable or even crucial to do so. We often hear of the importance of having cultural 'roots', but this botanical metaphor is only partial: in order

to grow, plants also need the light and carbon dioxide provided by their surrounding environment. Openness leads to vitality, and Chinese artists, one can argue, will not lose the ability to make works with rich and specifically local meaning as they become more fully a part of global culture.

Selected Bibliography

Andrews, Julia F. (1994), *Painters and Politics in the People's Republic of China, 1949–1979*, Berkeley: University of California Press.

Andrews, Julia F., and Kuyui Shen (1998), *A Century in Crisis: Modernity and Tradition in the Art of Twentieth Century China*, New York: Guggenheim Museum.

Brown, Claudia, and Chou Ju-hsi (1992), *Transcending Turmoil: Painting at the Close of China's Empire, 1796–1911*, Phoenix: Phoenix Art Museum.

Chang, Arnold (1980), *Painting in the People's Republic of China: The Politics of Style*, Boulder: Westview Press.

Chinese Culture Foundation of San Francisco (1989), *Wu Guanzhong: A Contemporary Chinese Artist*, San Francisco: Chinese Culture Foundation of San Francisco.

Clarke, David (1996), *Art and Place: Essays on Art from a Hong Kong Perspective*, Hong Kong: Hong Kong University Press.

Clunas, Craig (1997), *Art in China*, Oxford: Oxford University Press.

Cohen, Joan Lebold (1987), *The New Chinese Painting, 1949–1986*, New York: Abrams.

Croizier, Ralph (1988), *Art and Revolution in Modern China: The Lingnan (Cantonese) School of Painting, 1906–1951*, Berkeley: University of California Press.

Doran, Valerie C., ed. (1993), *China's New Art, Post-1989*, Hong Kong: Hanart TZ Gallery.

Driessen, Chris, and Heidi van Mierlo, eds. (1997), *Another Long March: Chinese Conceptual and Installation Art in the Nineties*, Breda: Fundament Foundation.

Fu Shen (1991), *Challenging the Past: The Paintings of Chang Dai-chien [Zhang Daqian]*, Seattle: University of

Washington Press (in association with the Arthur M. Sackler Gallery, Smithsonian Institution, Washington DC).

Gao Minglu, ed. (1998), *Inside Out: New Chinese Art*, San Francisco: San Francisco Museum of Modern Art, Asia Society Galleries, and University of California Press.

Hong Kong Arts Centre (1992), *The Art of Lin Fengmian*, Hong Kong: Hong Kong Arts Centre.

Hong Kong Museum of Art (1995), *Homage to Tradition: Huang Binhong*, Hong Kong: Hong Kong Museum of Art.

Hong Kong Museum of Art (1995), *Twentieth Century Chinese Painting: Tradition and Innovation*, Hong Kong: Hong Kong Museum of Art.

Hong Kong Museum of Art (1988), *The Art of Xu Beihong*, Hong Kong: Hong Kong Museum of Art.

Hsü, Immanuel C. Y. (1995), *The Rise of Modern China*, Fifth Edition, New York: Oxford University Press.

Journal of the Oriental Society of Australia (1997), 'Special Issue on Chinese Art', Vol. 29.

Kao Mayching, ed. (1988), *Twentieth-Century Chinese Painting*, Hong Kong: Oxford University Press.

Laing, Ellen Johnston (1988), *The Winking Owl: Art in the People's Republic of China*, Berkeley: University of California Press.

Leymarie, Jean (1979), *Zao Wou-Ki [Zhao Wuji]*, Barcelona: Ediciones Poligrafa, S.A..

Li Chu-tsing (1979), *Trends in Modern Chinese Painting*, Ascona: Artibus Asiae Publishers.

McDougall, Bonnie S. (1980), *Mao Zedong's 'Talks at the Yan'an Conference on Literature and Art': A Translation of the 1943 Text with Commentary* (Michigan papers in Chinese studies, no. 39), Michigan: Center for Chinese Studies, The University of Michigan.

Noth, Jochen, Wolfger Pöhlmann, and Kai Reschke, eds. (1994), *China Avant-Garde: Counter-Currents in Art and Culture*, Hong Kong: Oxford University Press.

Silbergeld, Jerome (1987), *Mind Landscapes: The Paintings of C. C. Wang [Wang Jiqian]*, Seattle: University of Washington Press.

Sullivan, Michael (1996), *Art and Artists of Twentieth Century China*, Berkeley: University of California Press.

Taipei Fine Arts Museum (1990), *Paintings by Liu Kuo-sung [Liu Guosong]*, Taipei: Taipei Fine Arts Museum.

Tao Yongbai, ed. (1988), *Oil Painting in China, 1700–1985*, Nanjing: Jiangsu Art Publishing House.

Index

Italicized page references refer to in-text illustrations.